P9-DBO-164

Pastel
Step by Step

by Marla Baggetta

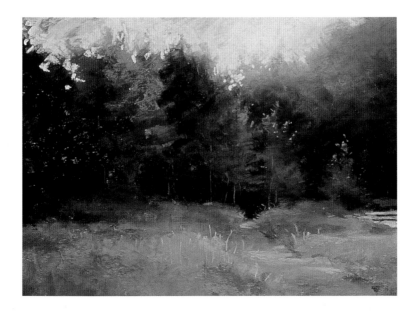

Walter Foster Publishing, Inc.
23062 La Cadena Drive
Laguna Hills, CA 92653
www.walterfoster.com

Contents

Introduction

If you like working with color, then you'll love pastels! Pastel has recently experienced a renewed popularity as a serious painting medium, and several manufacturers now make high-quality materials readily available to artists. Pastels are easy to use, and you don't have to worry about drying times, toxicity, or odors—as you might if you were working with paint. And pastel is also attractive to many artists because of its versatility—it is both a painting and a drawing medium. Moreover, you can create a seemingly endless variety of textures and effects with the vast number of hues that are available. And pastel is an extremely fluid and forgiving medium, which makes it great for beginners.

I've tried many other media throughout the years, but I always seem to come back to pastel. It is now my medium of choice, and I work almost exclusively in soft pastel. In this book, I'll demonstrate a variety of techniques and show you how to render an array of subject matter—we'll even explore working with different artistic styles. As you learn more about the vibrant and fascinating world of pastel, you'll begin to recognize the endless possibilities that this medium has to offer!

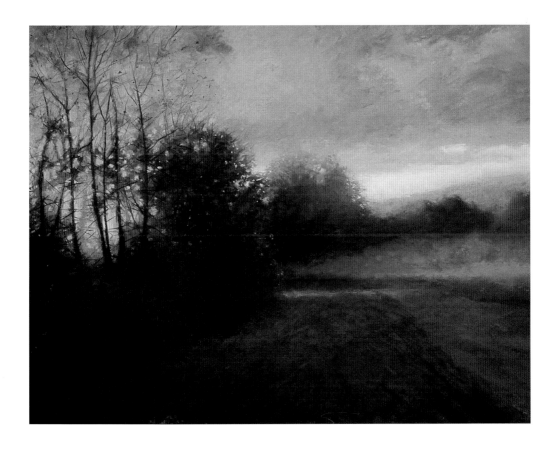

Tools and Materials

Although you won't need a lot of supplies to work in pastel, you will want a large assortment of colors. You can't mix pastel colors on a palette (as you would with paint) before applying them to the support—you must layer and blend them directly on the paper itself. But pastels are available in thousands of colors, and since they never "expire," you can buy as many colors as you like and keep them indefinitely. Most pastel manufacturers offer sets that contain a variety of colors and values. (For more on values, see page 6.) If you're a beginner, buying sets is a good way to start building your collection; you can always purchase additional individual pastels later. For the projects in this book, I've listed the colors I use at the beginning of each lesson. Of course you can substitute similar colors, but your results may differ from mine.

Pastels

There are two styles of pastel available: chalk-based pastels and oil pastels. In this book, I use a combination of the three types of chalk-based pastel—hard, clay-based sticks; soft pastel sticks; and pastel pencils. Hard pastels are good for underpainting (see page 12) and filling in large areas, while the buttery consistency of soft pastels makes them ideal for soft blends and smooth textures. Pastel pencils provide precise control and brilliant color, making them a good choice for detail work.

Choosing Pastels Remember that it's important to buy the best quality of materials that you can afford: Artist-grade pastels contain more pigment and less binder than the inexpensive student-grade ones, making artist-grade more vibrant and less likely to crumble.

Choosing a Support Don't let the staggering array of available supports overwhelm you; you can limit your selection somewhat by sticking to archival-quality papers, which are specially treated to retain the brilliance of the pigment you apply. This way your work will remain as vibrant as when you first created it.

Supports

The paper you work on—your *support*—contributes greatly to the effects you achieve. There are three important aspects to consider when you're choosing a support: The *tooth* (or the grain), the tone, and the color. The tooth can be rough or smooth; the tone can be dark or light; and the color can be cool, warm, or neutral. (For more on color, see pages 6–7.) Rough papers are best for thick layers of pigment, while smooth papers have less tooth, so they are better for soft blends and detail work. The tone and the color of the support you choose will affect the mood of your subject; cool, dark papers can evoke a dramatic feeling, while lighter, warmer papers may create a more lighthearted feeling.

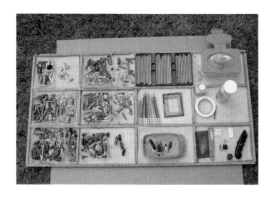

Organizing Pastels When I paint, I arrange my pastels on a plywood tray I built myself. I lined each section with foam to help keep the pastels clean and to prevent them from rolling around and breaking. I also have room on my tray for my other tools, as well as space for expansion—I'm always collecting new colors!

Sharpening Tools To sharpen soft pastel sticks, I use a sandpaper pad or a drywall screen. When sharpening hard pastel sticks, I prefer using a utility knife. Most pastel pencils can be sharpened with a small hand-held pencil sharpener or an electric sharpener.

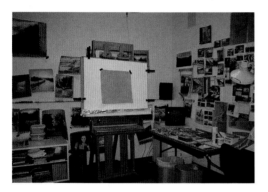

Setting Up a Workspace My workspace is arranged so that everything I need is nearby and easily accessible. I set up my easel with a trap underneath to collect any excess pastel dust. My support is fairly vertical—this way, the pastel dust will fall into the trap instead of onto the floor. For health and safety reasons, I always keep my workspace well ventilated so I don't breathe in the pastel dust.

Painting Outdoors

Painting outdoors, or *en plein air,* is a great way to observe your subject. And pastels are perfect for painting on site—they are easy to transport and there's virtually no cleanup involved. When I paint outdoors, I use a French easel (also called a "pochade") with a custom-made tray that accommodates all my pastels. When setting up, I usually face my easel toward the sun so the shadow of my easel shields my pastels and keeps my working surface shaded. When traveling or painting outdoors, I keep my pastels in tight-lidded plastic containers filled with cornmeal. This system not only keeps the pastels clean, but also assures they will stay unbroken during transport.

Bringing the Essentials There are a few extra items you might want to bring with you when you paint outdoors. It's always a good idea to have a hat and sunscreen, even on cloudy days, along with plenty of water, snacks, bug spray, a poncho in case it rains, and a charged cell phone. And don't forget handwarmers and a thermos of a warm beverage on cold days!

Color Theory

Since pastels are blended directly on the support, it's important to know the basics of color theory; this way, you can learn to mix color accurately. The *primary* colors (red, yellow, and blue) are the three basic colors that can't be created by mixing other colors; all other colors are derived from these three. The *secondary* colors (orange, green, and purple) are each a combination of two primaries, and the *tertiary* colors (red-orange, red-purple, yellow-orange, yellow-green, blue-green, and blue-purple) are each a combination of a primary color and a secondary color. Each color is referred to by its *hue*, or name, (such as green or blue) and its *saturation* or intensity (its relative brightness or dullness).

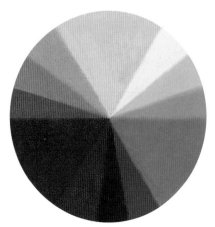

Color Wheel Knowing where each color lies on the color wheel will help you understand how colors relate and interact with one another; it will also help you understand how to mix and blend your own pastel hues.

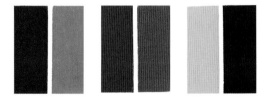

Using Complements *Complementary* colors are any two colors directly across from each other on the color wheel (such as red and green, orange and blue, or yellow and purple). When placed next to each other, complementary colors can create lively contrasts in your artwork. When blended, they neutralize each other, creating fresh grays and browns.

Value

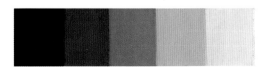

Value refers to the relative lightness or darkness of a color—or black. Effectively manipulating value creates the illusion of form in a painting. The concept of value is especially important when working with pastel, as pastel manufacturers produce each hue in a variety of values, from light to dark. They label their pastels using a numbering system to identify the strength of each color. (For example, one manufacturer labels the pure color as "5," with the lightest value being "1" and the darkest "9." Another brand uses decimal points to denote the proportion of white that has been added to the pure hue.) Unfortunately these numbering systems are not standardized among brands. When you purchase pastels, compare the labels carefully to determine how that particular manufacturer indicates the values of its colors.

Making a Value Scale A value scale starts with a dark value of a color (or black), progresses through values of gray which gradually become lighter, and finally becomes almost white. This value scale demonstrates the value progression of black to white. Creating a value scale like this will be a helpful reference tool as you paint; refer to it often to help you see the variations of value in your subjects.

Tints, Shades, and Tones

When pastel manufacturers create various values of the same color, they add white to make it lighter, creating a *tint*, or they add black to make it darker, creating a *shade*. To mute a color, gray is added, creating a *tone*. You can expand your pastel palette by purchasing a variety of tints, shades, and tones from the manufacturer, or you can experiment with creating your own mixtures by blending white, black, or gray into your colors.

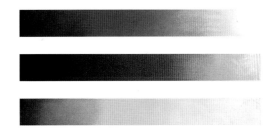

Creating Tints and Shades In this example, the pure color is in the middle of each bar. Black was blended in at the left and white at the right. When creating your own tints and shades, keep the layers of color light so that you don't fill the tooth of the paper; that way it will still be able to hold more pigment.

Color Psychology

Colors are often referred to in terms of "temperature," but that doesn't mean actual heat. An easy way to understand color temperature is to think of the color wheel as divided into two halves: The colors on the red side (red, orange, and yellow) are considered *warm*, while the colors on the blue side (blue, green, and purple) are considered *cool*. Thus colors with red or yellow in them also appear warmer, and colors with more green or blue in them appear cooler. For instance, if a normally cool color (like green) has more yellow added to it, it will appear warmer; and if a normally warm color (like red) has a little blue, it will seem cooler. Another important point to remember about color temperature is that warm colors appear to come forward and cool colors appear to recede; this knowledge is valuable when creating the illusion of depth in a scene. (See pages 22–25 for a demonstration of this principle in a pastel landscape.)

Comparing Warm and Cool Here the same scene is drawn with two different palettes; one warm (left) and one cool (right). Notice that the mood is strikingly different in each scene. This is because color arouses certain feelings; for example, warm colors generally convey energy and excitement, whereas cooler colors usually indicate peace and calm.

Expressing Mood The examples above further illustrate how color can be used to create mood (left to right): Complements can create a sense of tension; cool hues can evoke a sense of mystery; light, cool colors can provide a feeling of tranquility; and warm colors can impart a sense of danger.

Pastel Techniques

Unlike painting with a brush, working with pastel allows you to make direct contact with the support. Therefore you have much more control over the strokes you make, the way you blend the pigment, and the final effects. Once you learn and practice the techniques shown here, you'll know which ones will give you the results you desire.

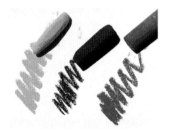

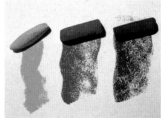

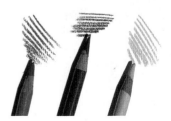

Firm Strokes Use the ends of the pastel sticks to create thick, bold strokes. The more pressure you apply, the thicker the stroke will be. These strokes are ideal for rendering large textured areas, such as fields of grass .

Side Strokes To quickly cover the support and fill in areas of broad color, drag the side of the stick across the support. I use this technique frequently to create skies, water, and under-paintings.

Pencil Lines Pastel pencils offer the most line control, as they are less likely to crumble or break than other types of pastel. If sharp, they can produce a very fine line, which is ideal for creating details or textures, such as fur or hair.

Handling Pastels

The way you hold and manipulate the pastel stick or pencil will directly affect the resulting stroke. Some grips will give you more control than others, making them better for detail work, and some will allow you to apply more pigment to the support to create broad coverage. And the pressure you exert will affect the intensity of the color and the weight of the line you create. Experiment with each of the grips described below to discover which are most comfortable and effective for you.

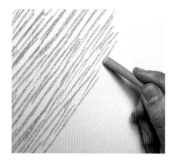

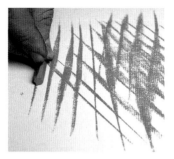

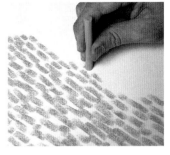

Linear Strokes To create linear strokes, grip the pastel stick toward the back end, and use your thumb and index finger to control the strokes. This grip is ideal for creating fine lines and details. However it offers less control than the other grips.

Broad Strokes Place the pastel flat on the paper and slide it back and forth to create broad linear strokes. This grip is also useful to create a "wash"; use the length of the pastel to cover large areas and create back-grounds quickly.

Round Strokes Turn the pastel stick on its end and grip it toward the front to create short, rounded strokes. This grip is perfect for creating texture quickly in large areas. Try overlapping the rounded strokes to create a denser texture.

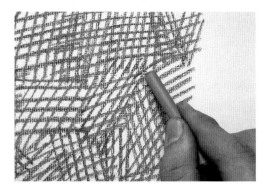

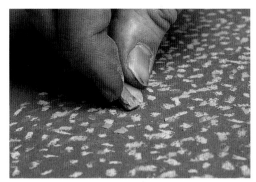

Crosshatching *Hatched* strokes are a series of parallel lines; *crosshatched* strokes are simply hatched lines layered over one another, but in opposite directions. You can crosshatch strokes of the same color to create texture or use several different colors to create an interesting blend.

Pointillism Another way to build up color for backgrounds or other large areas of color is to use a series of dots, a technique called "pointillism." This technique creates a rougher, more textured blend. When viewed from a distance, the dots appear to merge, creating one color.

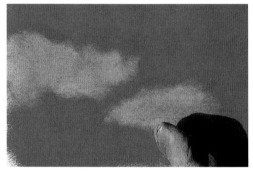

Removing Pigment When you need to remove color from a given area, use a kneaded eraser to pick up the pigment. The more pressure you apply, the more pigment will be removed. Keep stretching and kneading the eraser to expose clean, new surfaces.

Creating Patterns To create textures or patterns when rendering fabric or clothing, first lay down a solid layer of color using the side of the pastel stick or pencil. Then use the point of a pastel pencil to draw a pattern, using several different colors if you wish.

Using Tape You can create straight, even edges by using house painter's tape. Just apply it to your support, and make sure the edges are pressed down securely. Apply the pastel as you desire, and then peel off the tape to reveal the straight edges.

Gradating on a Textured Support Creating a smooth, even gradation on a textured ground can be a little tricky. Add the colors one at a time, applying the length of the stick and letting it skip over the texture of the paper by using light pressure.

Glazing Create a "glaze" just as you might with watercolor by layering one color over another. Use the length of the pastel stick with light pressure to skim over the paper lightly. The result is a new hue—a smooth blend of the two colors.

9

Blending Pastels

There are a number of ways to blend pastel, and the method you use depends on the effect you want to achieve and the size of the area you're blending. Smooth, even blends are easy to achieve with a brush, a rag, or even your fingers. You can also use your finger or a paper blending stump to soften fine lines and details. Still another method is to place two or more colors next to each other on the support and allow the eye to visually blend them together.

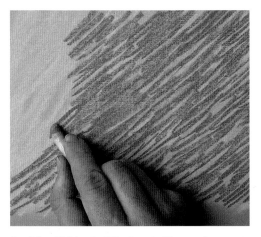

Applying Unblended Strokes In this example, magenta is layered loosely over a yellow background. The strokes are not blended together, and yet from a distance the color appears orange—a mix of the two colors.

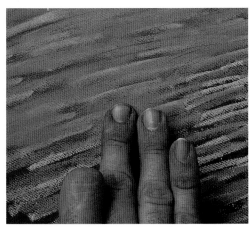

Blending with Fingers Using your fingers to blend gives you the softest blend and the most control, but be sure to wipe your hands after each stroke so you don't muddy your work. Or use rubber gloves to keep your hands clean.

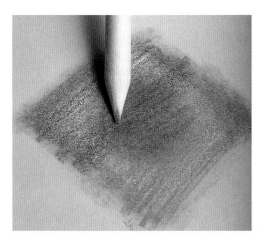

Blending with a Tortillon For blending small areas, some artists use a paper blending stump, or *tortillon*. Use the point to soften details and to reach areas that require precise attention.

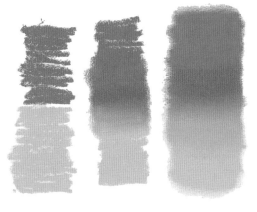

Creating a Gradation With soft pastel, you can create an even color gradation to depict sunset skies or smooth water. Just start with two spots of color, and then blend the area where they meet.

Masking

The dusty nature of pastel makes it hard to create clean, hard edges; but employing a simple masking technique is a great way to produce sharp edges. To mask, use a piece of paper or tape to create a straight edge (see page 9), or create a clean-edged shape with a special mask you make yourself. Of course, you would use tape only to save the white of the paper; never apply it to a support that already has pigment on it.

Cutting the Shape Begin by drawing the shape on a piece of tracing paper and cutting it out.

Applying the Color After painting the background, place the mask on top and then apply color.

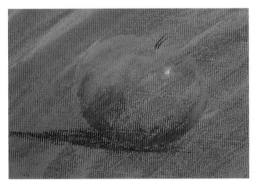

Removing the Mask Carefully peel away the mask to reveal the crisp shape underneath.

Using a Combination of Techniques

All of the techniques mentioned so far are useful in and of themselves, but you won't truly understand the effects you can achieve until you apply them to an actual subject. Here you can see how the same subject is rendered using three different methods; notice the different look each example has. Then practice creating some examples of your own.

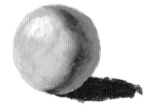

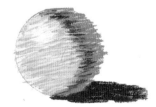

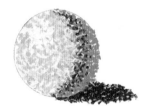

Blending Here the colors were applied thickly and smoothly; as you can see, the even layers of color create the appearance of a slick, smooth object.

Linear Strokes In this example, linear strokes are layered over one another to create a more textured appearance. From a distance, the colors still appear to blend together.

Pointillism In this case, pointillism is used to create the form of the sphere. Although the same colors are used, the surface of the object appears much rougher.

Approaching a Painting

The way you approach a painting in pastel is similar to painting in any other medium: Start with an undercolor and then build up the values from dark to light. I begin almost every painting I create (including the landscape shown here) by *toning* the support (applying a base color to cover the "white" of the support) with a wash of acrylic paint. Then I sketch or transfer my drawing to the support and begin blocking in and filling the main shapes. Next I determine the direction and intensity of the light source and begin to define the shapes. Then I work toward harmonizing the colors in the piece, developing the forms and values, and creating interest. Finally I refine the shapes and edges and add the details. When I'm done, it's easy to go back and adjust any areas that need attention by moving or even removing pigment.

Step One I begin by toning a piece of sanded pastel paper with a diluted wash of acrylic paint. Toning assures that none of the unpainted support will show and allows a bit of color to sparkle through subsequent layers of color, harmonizing the finished piece. For the wash, I make a mixture of half yellow ochre paint and half water, and then I brush it evenly over the entire support. (I use an inexpensive brush because the sanded paper will eventually destroy it.) I let the support dry for about 20 minutes, and then I roughly sketch the scene with a pastel pencil, using a color that matches the subject. I start adding color from the top so that the pastel dust falls on the unpainted portion of the support, preventing it from contaminating any areas I've already worked on.

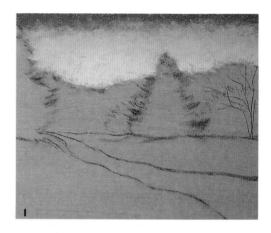

Step Two Next I block in the shapes of the darkest values in the scene, establishing the value relationships throughout the piece. Once I've placed the darks, I can judge the values of the midtones and lights based on how they compare to that darkest value. I always compare the values of the shapes in the subject to those around it; this way, I can determine the darkest darks and the lightest lights. These important contrasts in value create a sense of depth and realism in a painting.

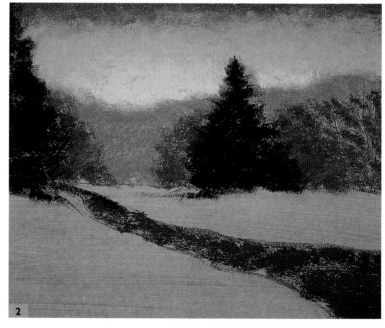

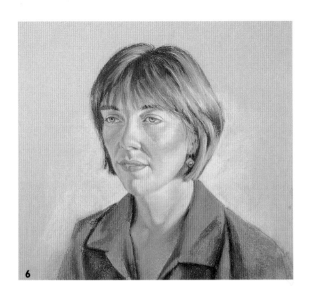

6

Step Six Next I add some reflected light under the lips with warm light gray, washing it over the small area carefully with very light pressure. Then I start to refine the hair by adding medium neutral gray highlights. I indicate a few individual strands, and then I use Van Dyke brown to darken the shadows in the hair and the eyebrows. I use the tip of the pastel stick to place the eyelashes with the same color. Then I place the shadow of the earring with a sepia hard pastel and the stone in the center with carmine.

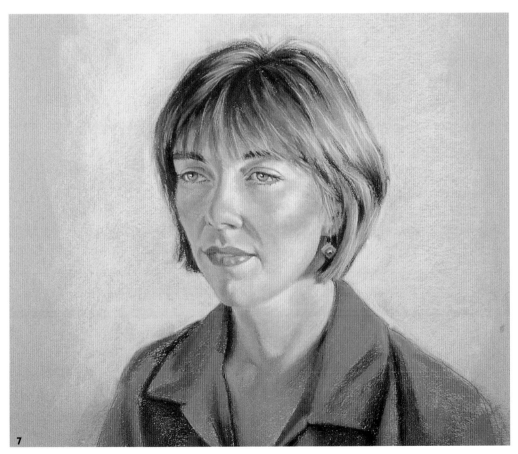

7

Step Seven I continue to refine the shapes of the hair, and then I add white highlights to the eyes. I create the highlights on the lips with flesh pink and blend the skin tones a bit with my fingers. Finally I add some more light gray to the background and blend it into the previous layer with my fingers. When I step back to assess my work, I try to objectively compare the photo with the finished piece to make sure I've achieved a good likeness.

Expressing a Theme

Sometimes using the same subject, color scheme, or style in series of paintings can be a wonderful way to find a focus in your work. Whether you want to make a bold artistic statement or simply capture a specific mood in a body of work, expressing a theme is a great way to expand yourself creatively. It can also help you develop your own style: When you determine a cohesive idea for a group of paintings, you'll start to discover the characteristics that distinguish your work, such as a tendency to paint loosely or a preference for a particular group of colors. Your theme can be as simple as summer gardens, figures, or animals in the wild. I recently decided to develop a group of paintings featuring different women in everyday settings. I chose to begin with a painting of a woman reading at home, and since reading is one of my favorite pastimes, I decided to make it a self-portrait. And because part of creating a theme is determining a style or approach, I chose to use bright colors and a more illustrative style to give these paintings an upbeat, contemporary feel.

Color Palette

HARD PASTELS: light gray PASTEL PENCILS: black, burnt carmine, burnt umber, caput mortuum, cobalt blue, deep ochre, deep purple, earth green, Indian red, indigo blue, lemon yellow, light chrome yellow, light flesh, light turquoise green, light ultramarine blue, manganese violet, medium flesh, medium green, permanent green olive, pine green, pink carmine, raw umber, sanguine, terra cotta, turquoise blue, Van Dyke brown, violet, and white

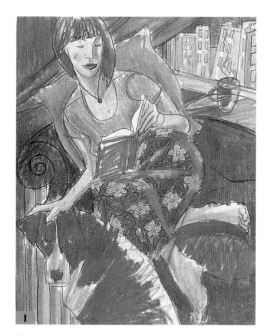

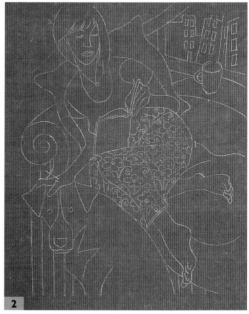

Step One I begin by sketching out my idea several times until I have what I want. Then I enlarge the sketch on a copy machine. I want to add a pattern to the skirt, so I work out the floral pattern on a separate piece of tissue paper and tape it over the photocopy of the sketch with transparent tape. Then I create a color sketch, using markers to work out my color scheme.

Step Two Next I tone a piece of sanded paper with cadmium red light acrylic paint. While that dries (about 20 minutes), I rub the back of the photocopy with a light gray hard pastel, covering the entire sheet to create a carbon. When the red paper is dry, I tape the copy to it at the top, carbon-side down. Then I use a sharp graphite pencil to trace over the lines to transfer the sketch to the support.

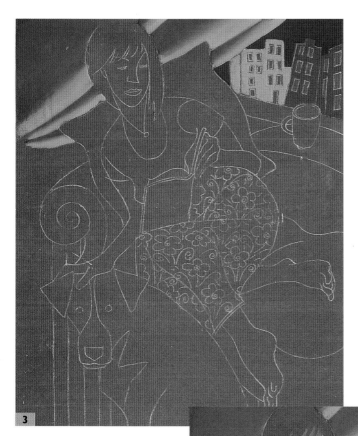

3

Step Three This painting is small (only about 8" × 10"), and it has quite a bit of detail, so I decide to use only pastel pencils for this piece. While working, I place a clean sheet of tracing paper under my hand so I won't smudge my piece. I start in the upper left with the curtain, using turquoise blue for the darks and light turquoise green for the lights. I press firmly, using the tip of the pastel pencil and blending the two colors together where the edges meet. I use manganese violet for the night sky, earth green for the building on the left, and pink carmine for the other building, and I leave the paper showing in the windows.

Step Four I fill in the pillow with permanent green olive and medium green, and I use Van Dyke brown for the hair. Then I color the shadowed shapes of the face, arms, and legs with caput mortuum. I leave a bit of the red paper showing around all the shapes to create an outline by not filling the shapes in completely. Later I will go back and create a more noticeable outline.

4

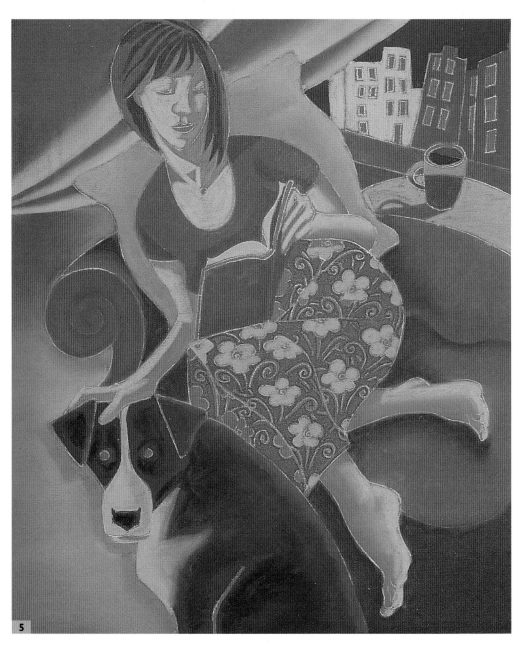

5

Step Five Next I use violet and manganese violet for the shirt, the ledge, and the coffee cup. Then I fill in the table with terra cotta and use a mix of burnt carmine and pink carmine for the couch. I fill in the dark areas on the dog with deep purple and black, blending the two colors slightly in some areas. Then I create the dog's lighter areas with light turquoise green and light ultramarine blue. I add medium flesh for the lights on the skin, and I place the darks in the hair with burnt umber. Next I fill in the pattern on the skirt with pine green and terra cotta, letting the color of the paper serve for the red lines in the pattern.

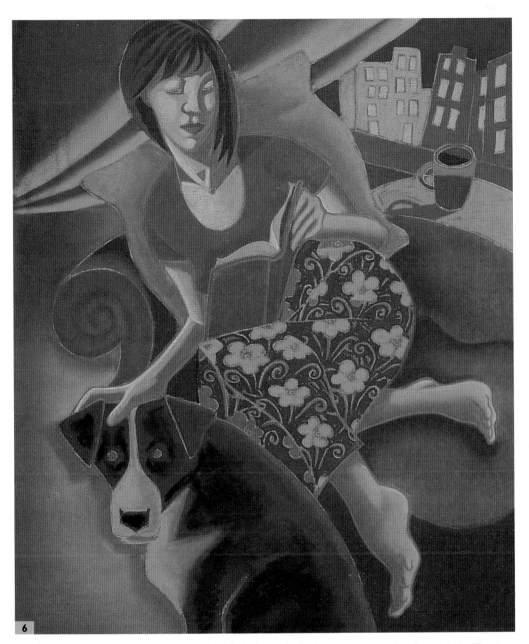

6

Step Six I place some highlights on the skin with light flesh, pressing firmly to cover the previous layers of color. Then I create the red mouth, using pink carmine for the lower lip and burnt carmine for the upper lip in shadow. Next I add the lights in the windows of the background buildings with light chrome yellow. At this point, I've filled in all my dark areas and mid-tones; next I'll focus on adding the lighter areas and the details.

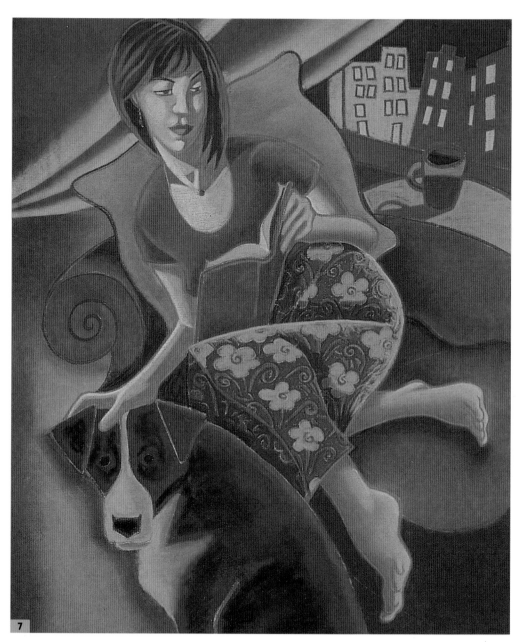

Step Seven Once all the shapes are filled in, I begin to outline the forms with a variety of colors. Sometimes I choose contrasting colors rather than similar ones to create variety and interest. For instance, here I use indigo blue around the left side of the pillow and Indian red around the right side. Then I add sanguine to the skin and draw the eyes, using cobalt blue for the iris and light ultramarine for the whites. I add the eyebrows with burnt umber, and then I indicate the earring, using burnt carmine for the teardrop-shaped bead and raw umber for the gold. I also add small, light strokes of light turquoise green for a highlight on the edge of the skirt.

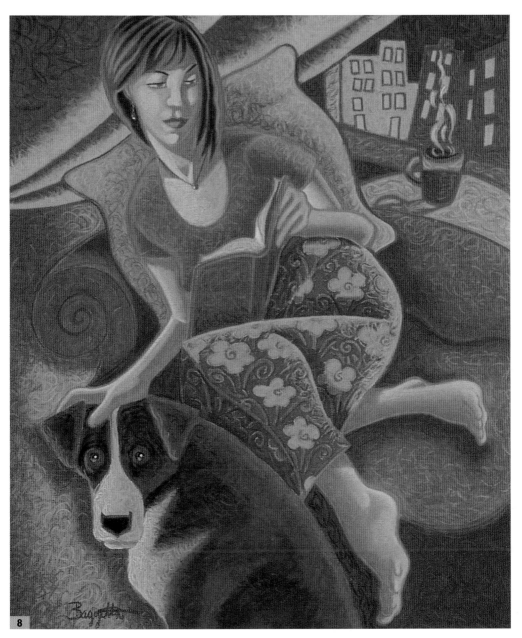

Step Eight For more interest, I decide to add a swirling texture to all the shapes except the skin areas. I apply the texture on the curtain with cobalt blue, pink carmine, and light turquoise green. For the pillow, I use light turquoise green and pine green. Then I add texture to the dog with cobalt blue and olive green. For the light areas of the couch, I use lemon yellow and pink carmine; for the areas in shadow, I use pink carmine and cobalt blue. I also complete the detail on the dog, adding the highlights in her eyes with deep ochre and white. Finally I add the steam from the coffee cup with light ultramarine and white, pressing firmly to cover the layers underneath.

Taking Artistic License

Once you've mastered the fundamentals of value, color, and composition, you can begin to take liberties with your subject matter. When an artist alters a subject by changing the viewpoint, adding or removing an element from the scene, or enhancing the color scheme, it's called "using artistic license." As you become more comfortable with altering your subject, you may want to take artistic license a step further and try creating a scene entirely from your own imagination—in other words, exercise artistic license with reality in general. In this painting, I began with an image from a dream I'd had and then experimented with various shapes, colors, values, perspectives, and lighting in small thumbnail sketches until I settled on one that appealed to me. To convey the feeling of awe and wonder in the image, I chose to use simple, distorted shapes and bright, unrealistic colors, which lend a surreal quality to the scene.

Color Palette

HARD PASTELS: light gray PASTEL PENCILS: alizarin crimson, black, bright olive green, cadmium red light, cadmium yellow, cobalt blue light, dark blue-green, dark violet, deep yellow, light ultramarine blue, magenta, permanent green deep, permanent rose deep, ultramarine blue, and white

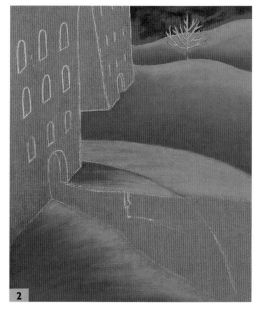

Step One After working out the composition and color scheme of my idea with a few quick thumbnail sketches, I tone a piece of sanded pastel paper with a cadmium red light acrylic wash and let it dry for about 20 minutes. Then I carefully transfer my final drawing to the support with a light gray hard pastel.

Step Two For this piece, I decide to use pastel pencils, which will let me achieve the fine detail I need. I start with black, ultramarine blue, and dark violet for the sky. Then I fill in the snowy hills with cobalt blue light and dark violet, starting with the hill in the background and moving toward those in the foreground.

Step Three Next I work on the distant building, using cadmium red light for the front of the building and magenta for the side. Then I use dark violet to achieve a slight gradation on the side of the building, which tones down the colors of the buildings a bit and allows the main focus to be on the figure. I blend the pigments as I work, pressing each color into the others around it. Then I fill in the windows with dark violet and black layered over one another. I also fill in the foreground building with bright olive green, pressing firmly to fill in the area thoroughly and evenly.

Step Four Next I use permanent green deep for a gradation on the face of the green building. Then I fill in the dark windows with ultramarine blue and black. I outline the windows with permanent rose deep, and then I use deep yellow, cadmium yellow, and white to fill in the brightly lit window. I apply cadmium yellow to the entire path, the doorway, and the doorjamb, leaving the paper blank where the figure will be. I don't butt the cadmium yellow up to the edge of the green building; instead I leave a tiny red outline around the door. Then I add deep yellow to the doorjamb, using white for the highlight at the bottom. I also use deep yellow to indicate the edge of the path at the right.

61

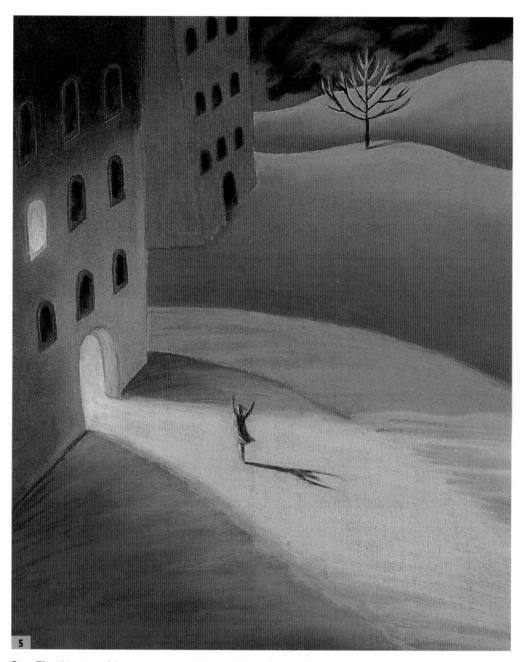

5

Step Five Next I carefully remove any remaining marks from the transferred drawing with a rubber eraser. Then I use black to draw the lower tree branches and ultramarine light to draw the upper branches. I fill in the entire shape of the figure with dark blue-green, and I use alizarin crimson to indicate reflected light on the shadow side of her shape. Next I add cadmium yellow to the light side and create the figure's cast shadow, adding alizarin crimson and dark blue-green where her body meets her shadow.

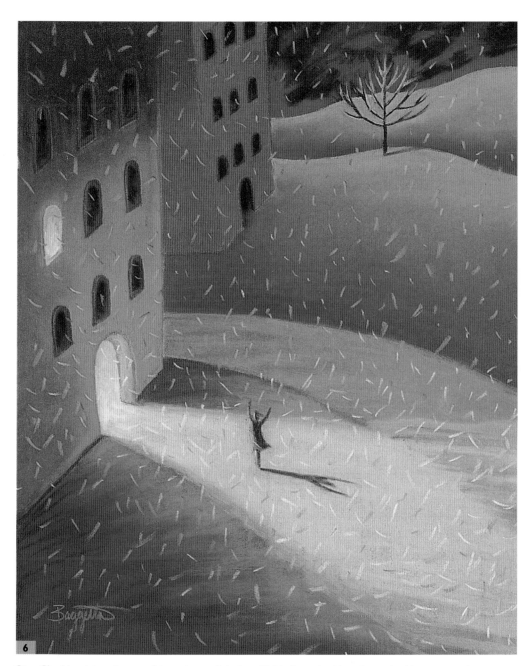

Step Six Now I draw the snowflakes using small strokes of light ultramarine blue, ultramarine blue, permanent green deep, and cadmium yellow, pressing firmly to make sure they are visible. I make smaller strokes to create more distant flakes, as well as larger strokes to indicate closer ones. The strokes are slightly curved to show that the snowflakes are floating gently downward. Then I sign my name!

Conclusion

No matter what subject you choose to explore in your artwork, the more you practice and experiment with pastel, the more you'll discover about the amazing results you can achieve. Keep your camera and sketchbook ready, because whatever captures your interest or your imagination is what will bring style and individuality to your work. Try working with different techniques and materials to find what works best for you, but most important—just keep painting. Use your imagination and enjoy working with pastel!